W9-AHB-424

S U N f L O W E R S

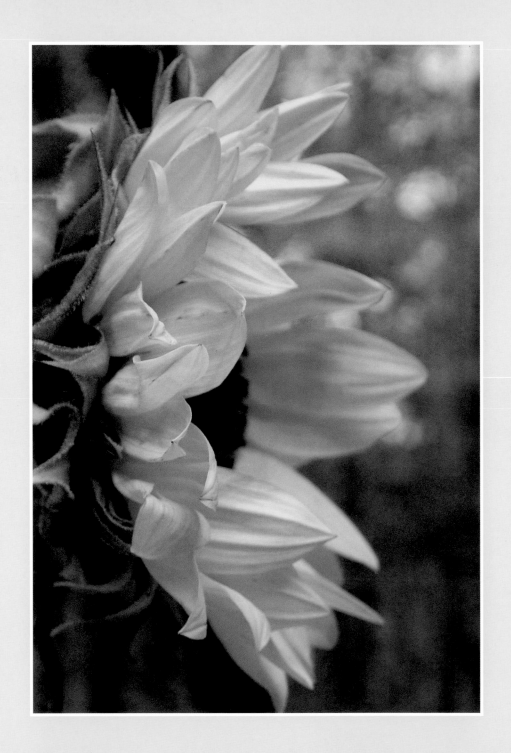

s u n f l o w e r s

COURAGE
BOOKS
AN IMPRINT OF RUNNING PRESS
PHILADELPHIA · LONDON

© 2004 by Running Press
All rights reserved under the Pan-American and
International Copyright Conventions

Printed in China

This book may not be reproduced in whole or in part, in any form or by any means,
electronic or mechanical, including photocopying, recording,
or by any information storage and retrieval system now known or hereafter invented,
without written permission from the publisher.

9 8 7 6 5 4 3 2 1
Digit on the right indicates the number of this printing

Library of Congress Control Number: 2004093939

ISBN 0-7624-2329-3

Cover and interior design by Frances J. Soo Ping Chow
Photography researched by Susan Oyama
Edited by Deborah Grandinetti
Typography: Perpetua

This book may be ordered by mail from the publisher.
But try your bookstore first!

Published by Courage Books,
an imprint of
Running Press Book Publishers
125 South Twenty-second Street
Philadelphia, Pennsylvania 19103-4399

Visit us on the web!
www.runningpress.com

Contents

Introduction

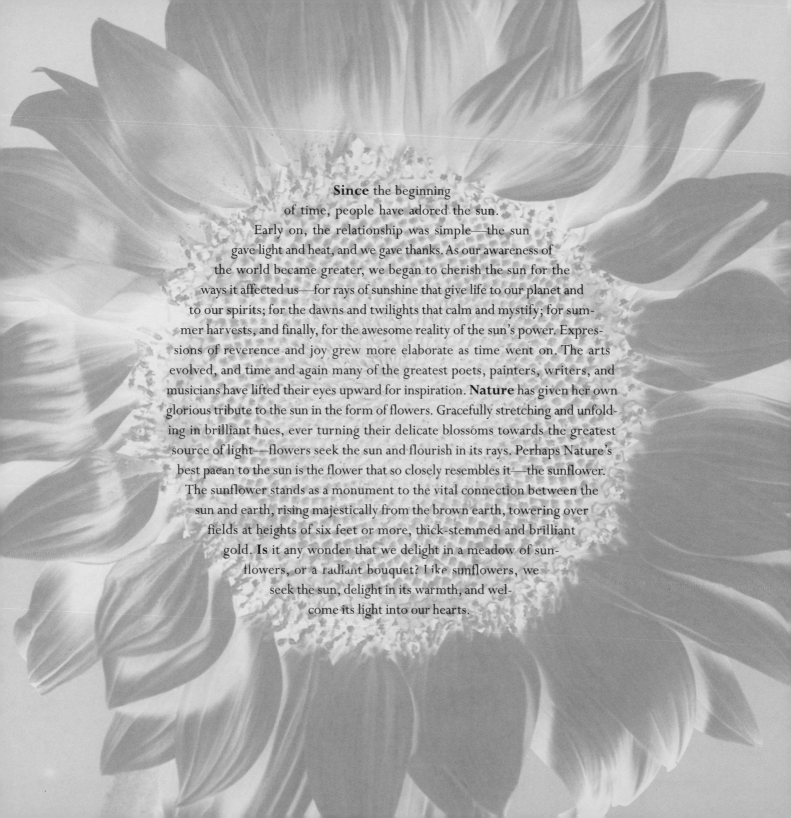

Since the beginning
of time, people have adored the sun.
Early on, the relationship was simple—the sun
gave light and heat, and we gave thanks. As our awareness of
the world became greater, we began to cherish the sun for the
ways it affected us—for rays of sunshine that give life to our planet and
to our spirits; for the dawns and twilights that calm and mystify; for sum-
mer harvests, and finally, for the awesome reality of the sun's power. Expres-
sions of reverence and joy grew more elaborate as time went on. The arts
evolved, and time and again many of the greatest poets, painters, writers, and
musicians have lifted their eyes upward for inspiration. **Nature** has given her own
glorious tribute to the sun in the form of flowers. Gracefully stretching and unfold-
ing in brilliant hues, ever turning their delicate blossoms towards the greatest
source of light—flowers seek the sun and flourish in its rays. Perhaps Nature's
best paean to the sun is the flower that so closely resembles it—the sunflower.
The sunflower stands as a monument to the vital connection between the
sun and earth, rising majestically from the brown earth, towering over
fields at heights of six feet or more, thick-stemmed and brilliant
gold. **Is** it any wonder that we delight in a meadow of sun-
flowers, or a radiant bouquet? Like sunflowers, we
seek the sun, delight in its warmth, and wel-
come its light into our hearts.

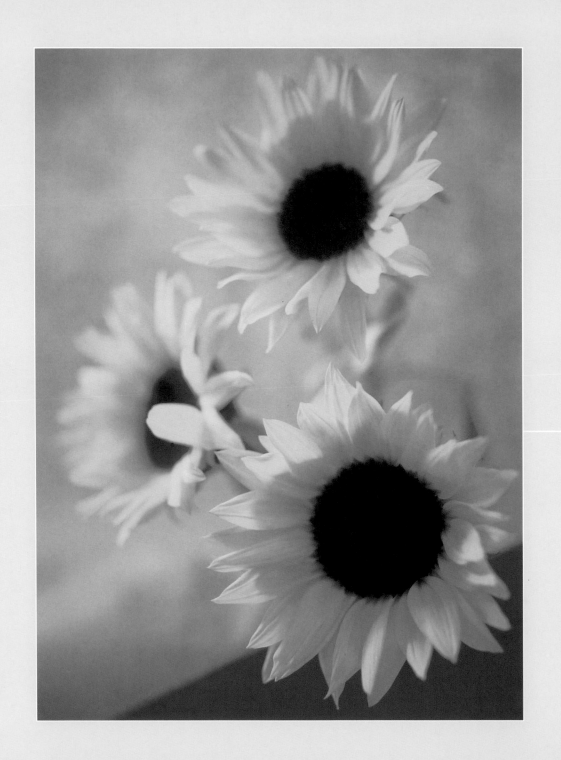

FLOWERS

Don't hurry, don't

WORRY.

You're only here for a

short visit.

So be sure to stop

and smell

THE FLOWERS.

Walter C. Hagen (1892–1969)
American golfer

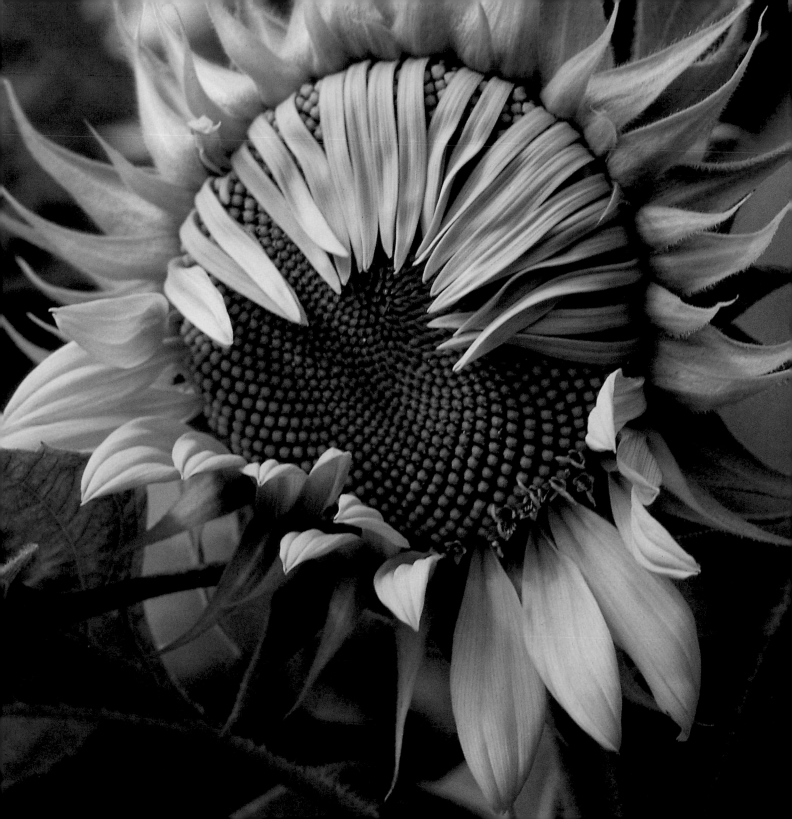

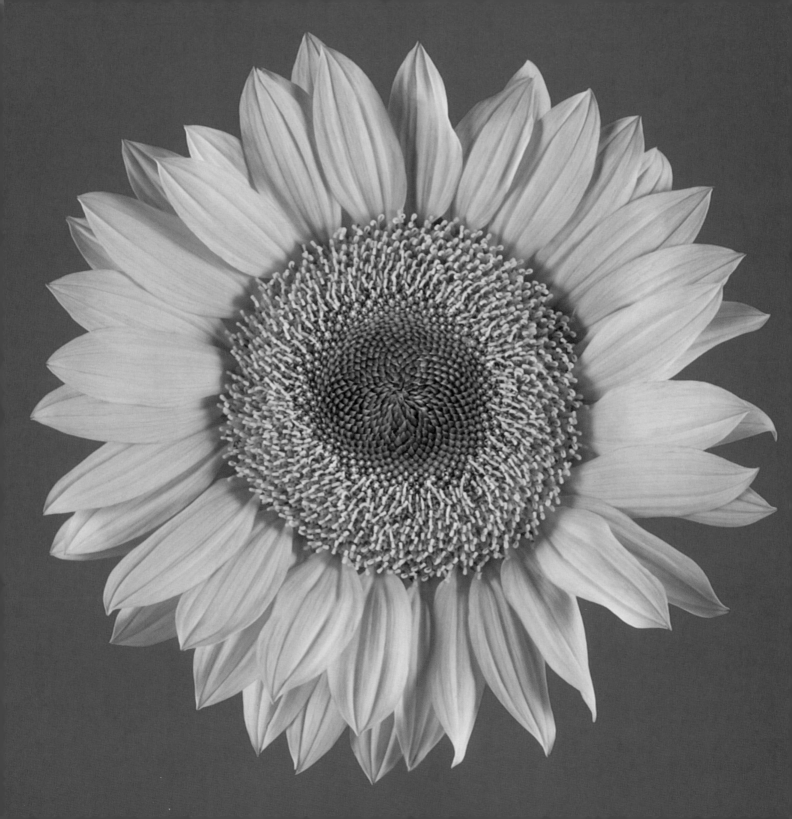

COLORS ARE

THE SMILES

OF NATURE...

THEY ARE

HER LAUGHS,

AS IN FLOWERS.

Leigh Hunt (1784–1859)
English writer

And 'tis

my faith that

every flower

Enjoys the air it breathes.

William Wordsworth (1770–1850)
English poet

The tiniest garden is often the loveliest.

Vita Sackville-West (1892–1962)
English poet and novelist

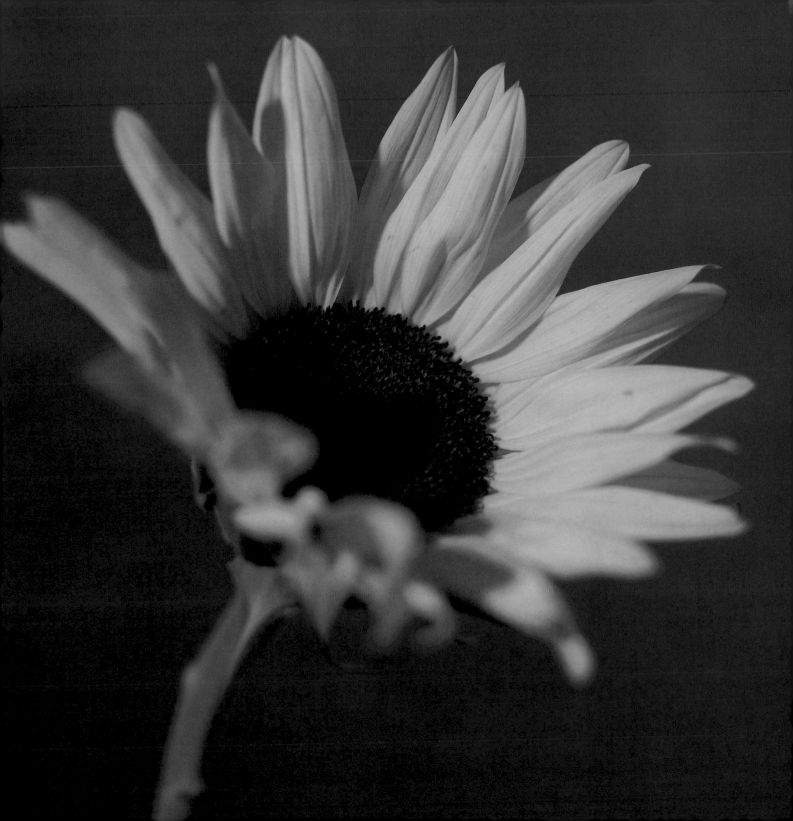

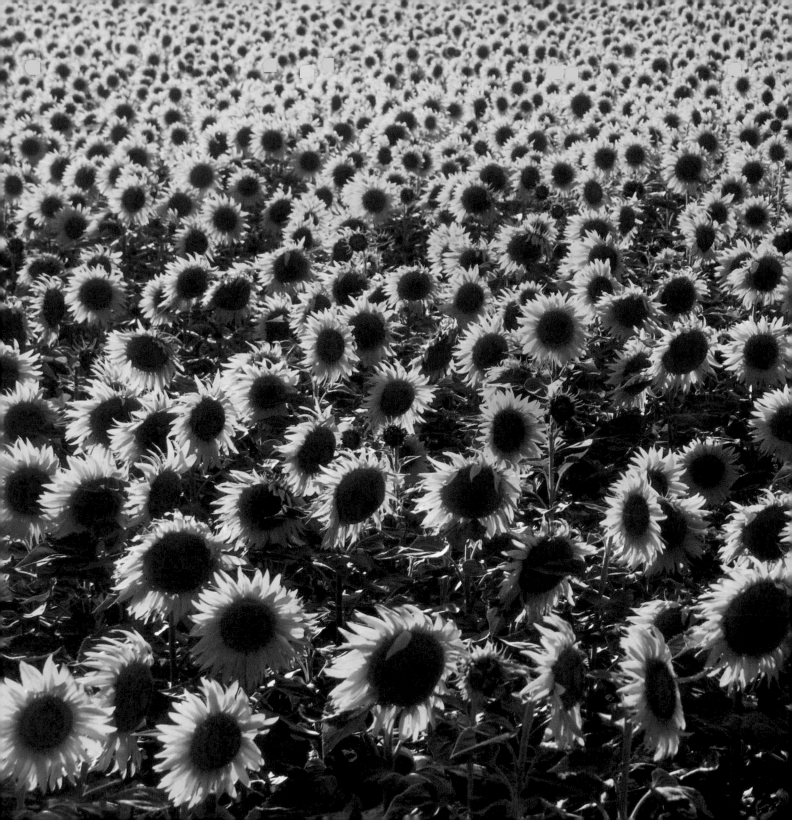

Wildflowers are perhaps

the most enchanting of all for me.

I love their delicacy,

their disarming innocence, and their

defiance of life itself.

Grace Kelly (1929–1982)
American-born actress and Princess of Monaco

FLOWERS AND PLANTS

ARE SILENT PRESENCES;

THEY NOURISH

EVERY SENSE

EXCEPT THE EAR.

May Sarton (1912–1995)
Belgian-born American writer

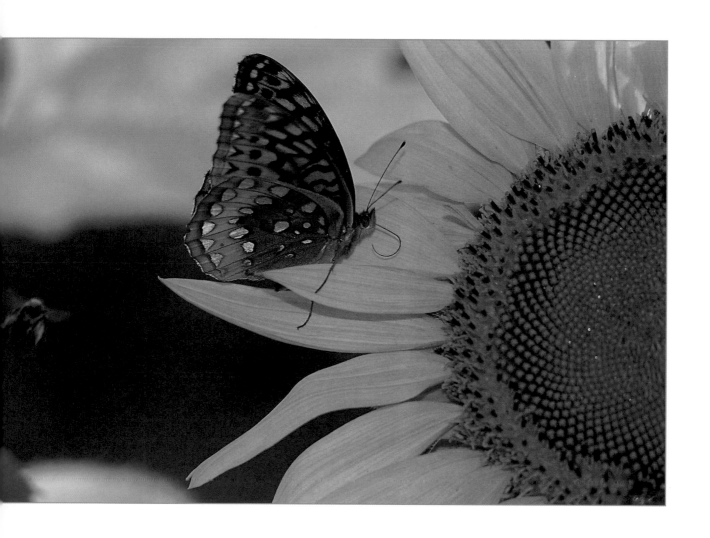

Flowers are restful to look at.
They have neither emotions nor conflicts.
Sigmund Freud (1856–1939)
Austrian founder of psychoanalysis

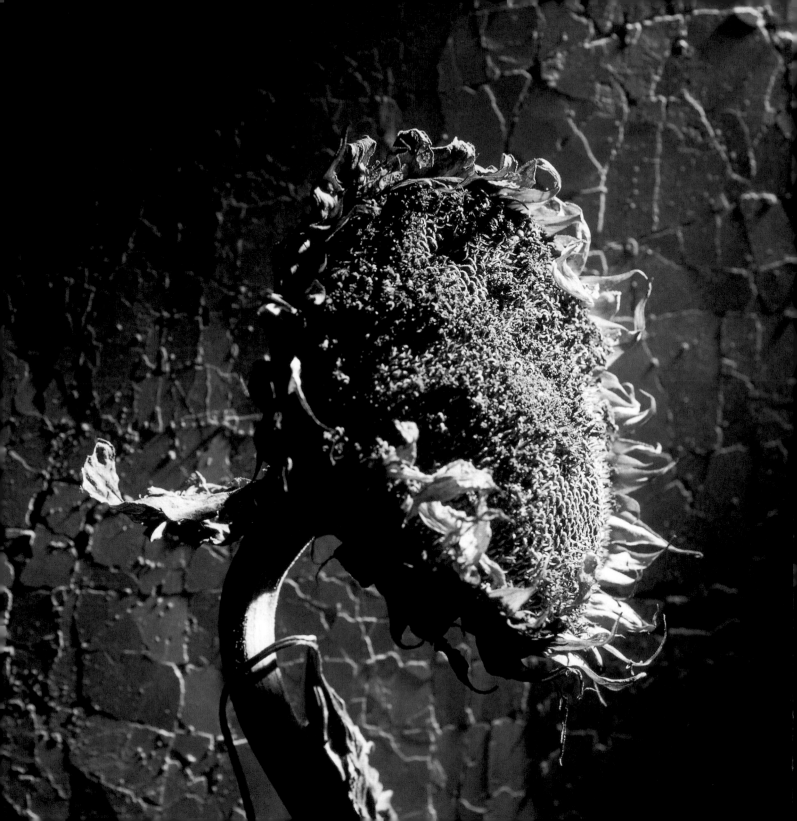

People from

A PLANET WITHOUT

flowers

would think we must be mad with

JOY

the whole time to have

such things about us.

Iris Murdoch (1919–1999)

The flowers take the tears of weeping night

And give them to the sun for the day's delight.

Joseph S. Cotter, Sr. (1861–1949)
American poet

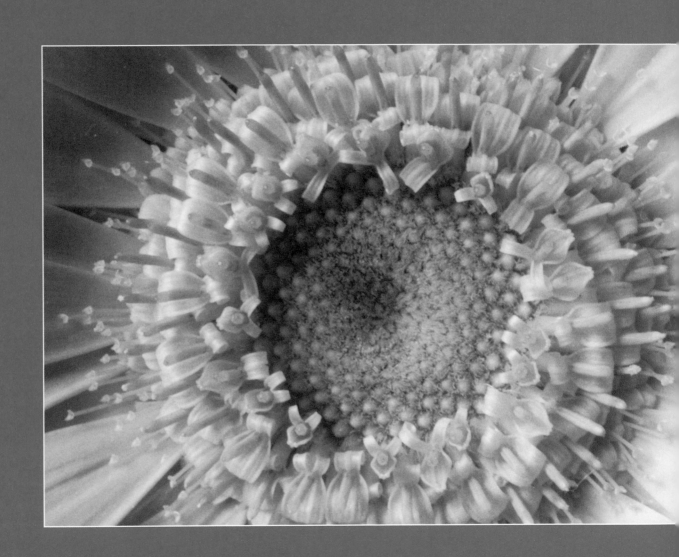

HAPPINESS

There is only one duty:

THAT IS TO BE HAPPY.

Denis Diderot (1713–1784)
French philosopher and translator

To be content with what we possess

is the greatest and most secure of riches.

Marcus Tullius Cicero (106–43 b.c.)
Roman orator, statesman, and philosopher

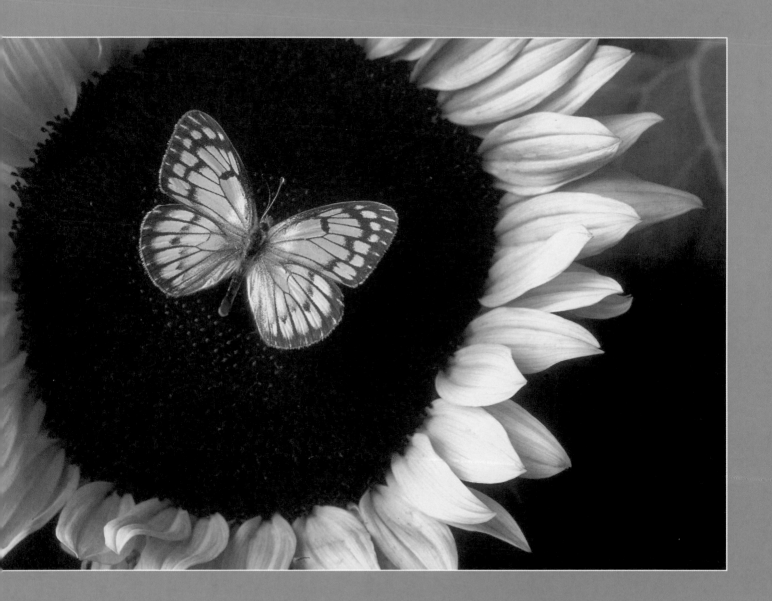

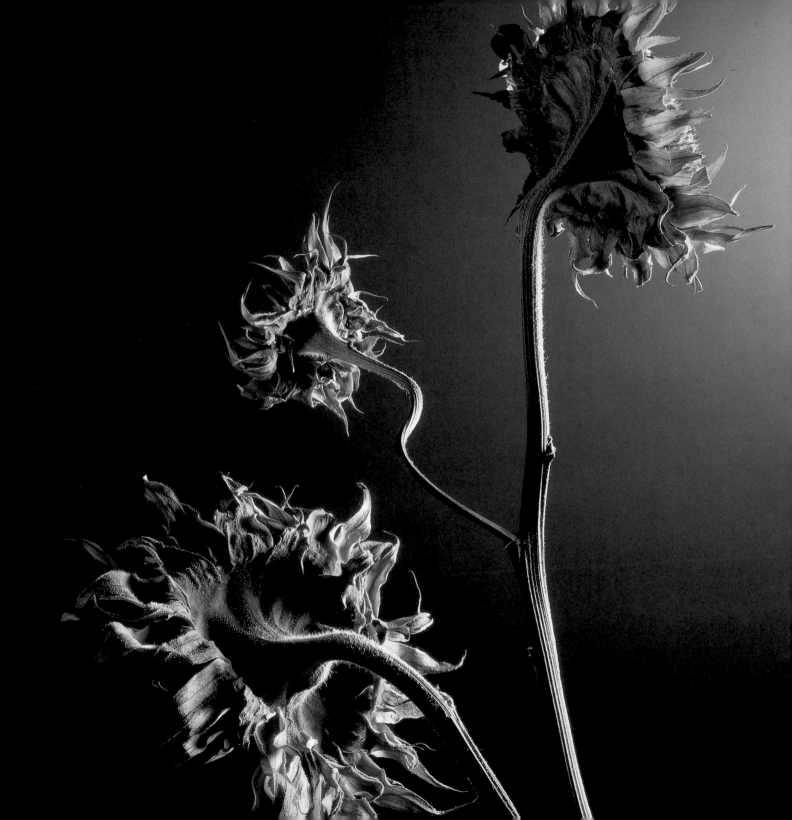

Do not seek

to have everything that happens

happen as you wish,

but wish

for everything to happen

as it actually does happen,

and your life will be

serene.

Epictetus (c. 55–135 A.D.)
Greek philosopher

HAPPINESS

IS NOT A POSSESSION

TO BE PRIZED,

IT IS A QUALITY

OF THOUGHT,

A STATE OF MIND.

Daphne du Maurier (1907–1989)
English writer

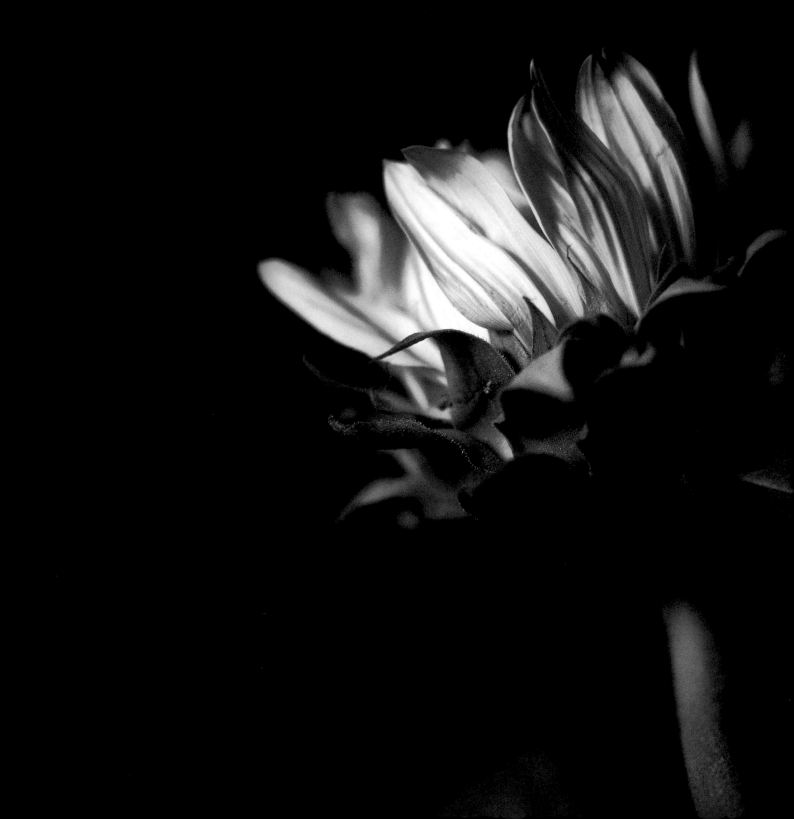

HAPPINESS

is when what you think, what you say,

and what you do are in harmony.

Mohandas Gandhi (1869–1948)
Indian leader

Happiness is a wine of the rarest vintage.

Logan Pearsall Smith (1865–1946)
American-born English writer

LOVE

the moment, and

the energy

of that moment

WILL SPREAD

beyond all boundaries.

Corita Kent (1918–1986)
American poet

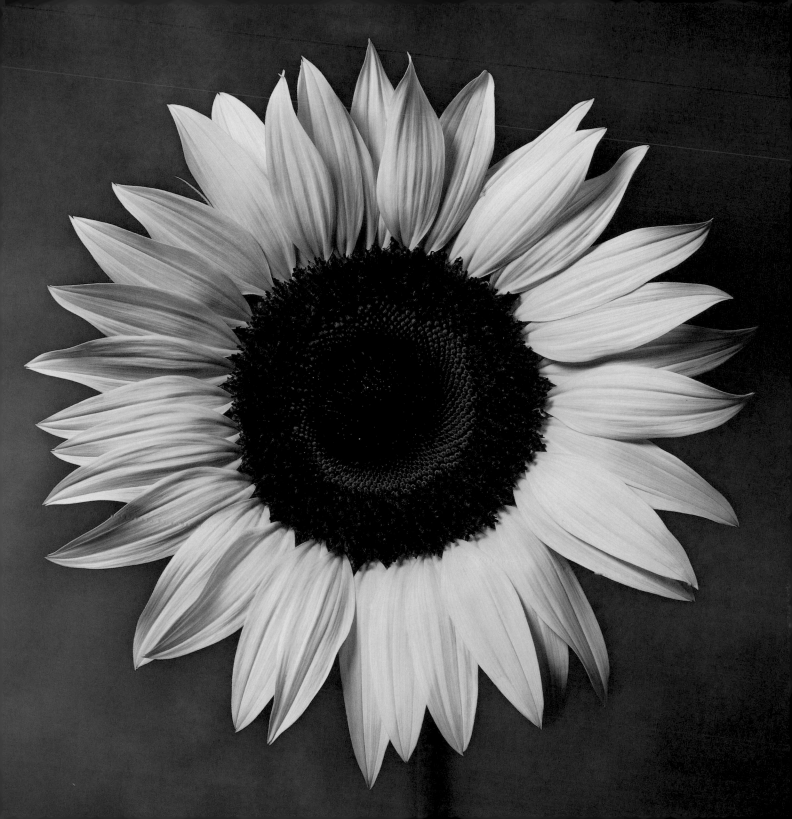

All

NATURE

wears

one

UNIVERSAL

grin.

Henry Fielding (1707–1754)
English novelist and playwright

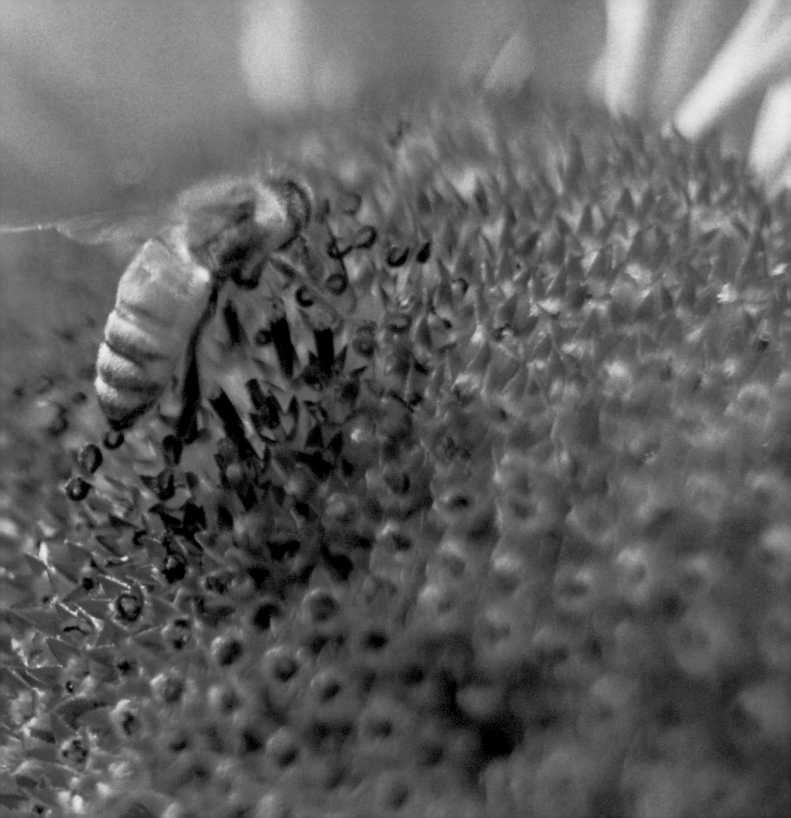

The most

CERTAIN

sign of

wisdom

is a continued cheerfulness. . . .

Michel de Montaigne (1533–1592)
French essayist and thinker

This is happiness;

to be dissolved into something complete and great.

Willa Cather (1876–1947)
American writer

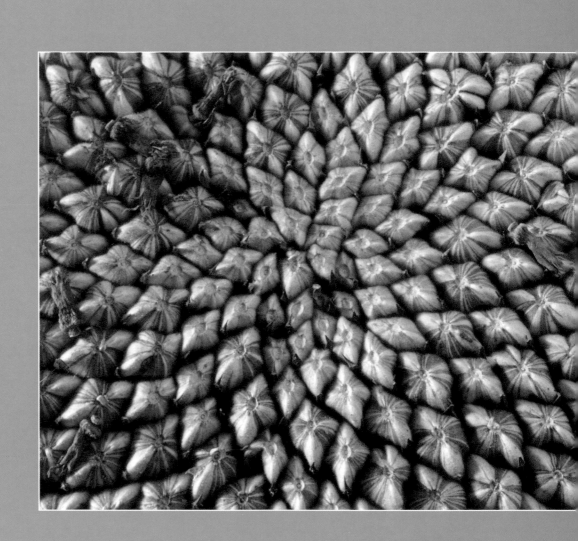

NATURE

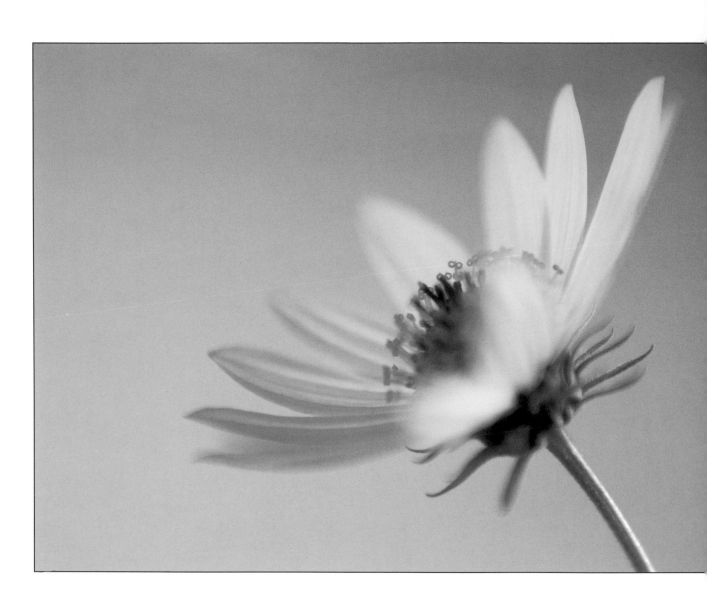

Nature does nothing uselessly.

Aristotle (384–322 B.C.)
Greek philosopher

A nature lover

is someone who, when treed

b y a b e a r ,

ENJOYS THE
VIEW.

Anonymous

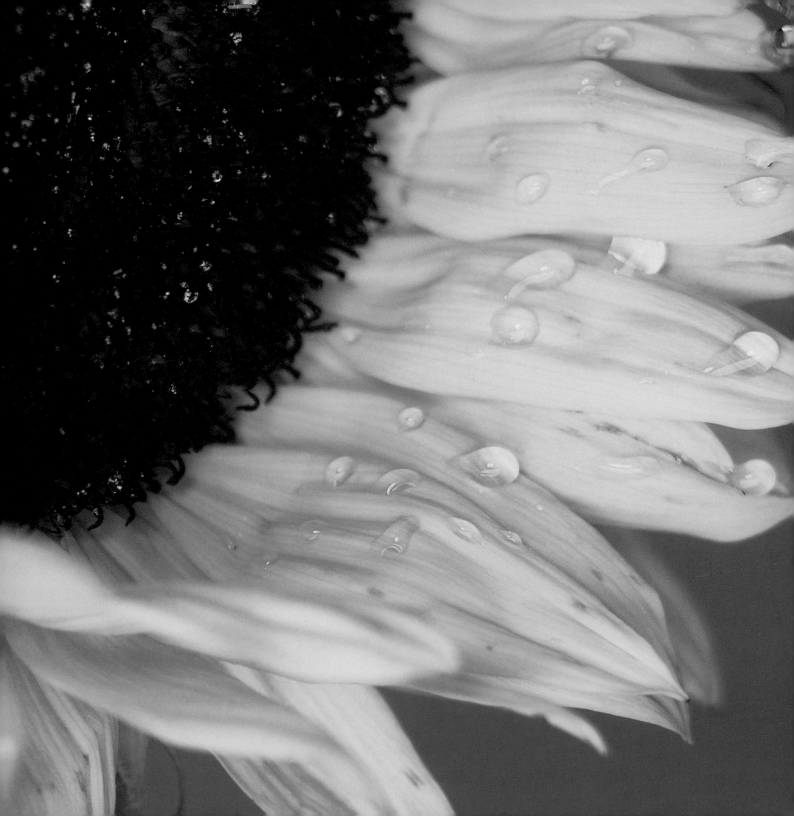

The world stands out

on either side

No wider

than the heart is wide;

Above the world

is stretched the sky,

No higher than the soul

is high.

Edna St. Vincent Millay (1892–1950)
American poet

. . . [Nature] is the one place where
miracles not only happen, but happen all the time.

Thomas Wolfe (1900–1938)
American novelist

OUR JOYRIDES WERE

HORSEBACK RIDES.

WILD DASHES ACROSS

THE PRAIRIE,

THE WIND PAINTING

OUR CHEEK WITH

NATURE'S RED.

Catherine Cavender
19th-century American pioneer

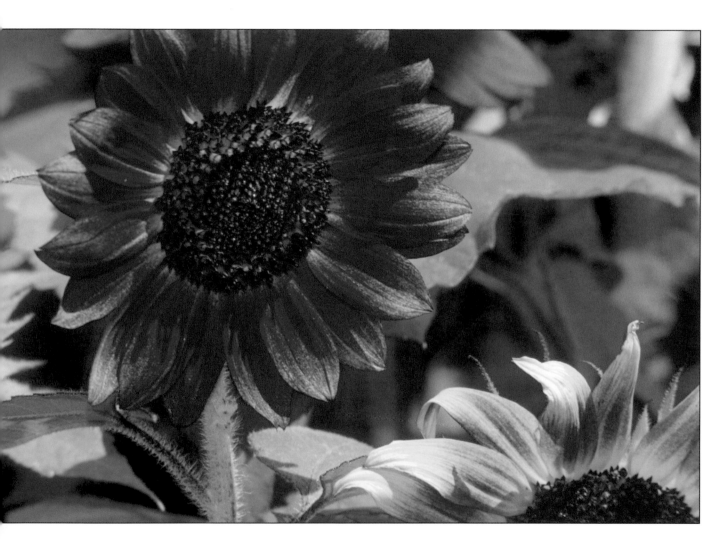

I am at two with nature.

Woody Allen (b. 1935)
American actor, comedian, writer

Anyone who
has got any pleasure at all
from nature should
try to put something back.

Gerald Durrell (1925–1995)
English conservationist and writer

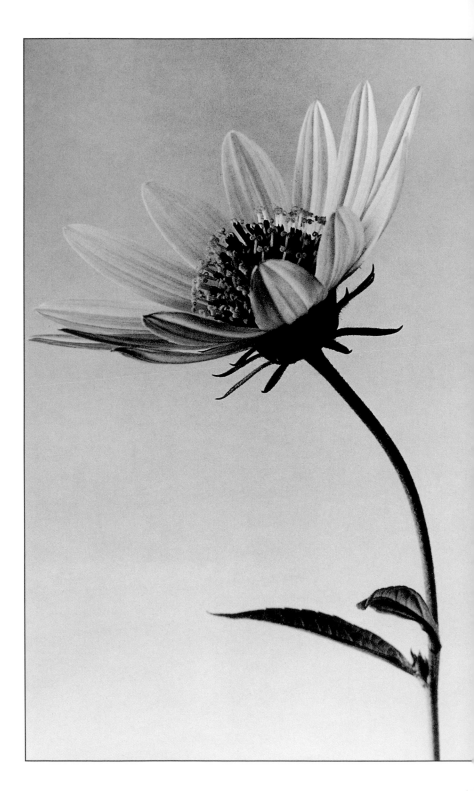

To see a World in a Grain of Sand

And a Heaven

in a wild Flower,

Hold Infinity in the palm of your hand

And Eternity in

an hour.

William Blake (1757–1827)
English artist and poet

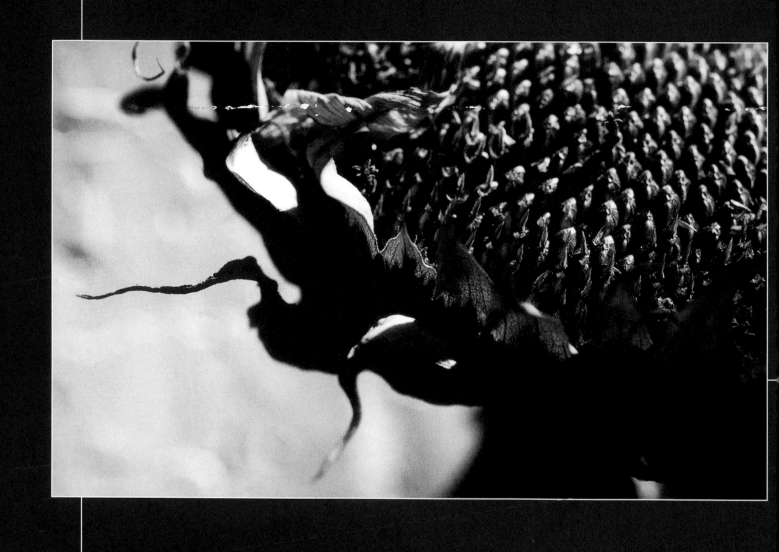

EXPRESSION

ART IS THE

UNCEASING EFFORT

TO COMPETE WITH

THE BEAUTY OF

FLOWERS—

AND NEVER

SUCCEEDING.

Marc Chagall (1887–1985)
Russian-born French artist and writer

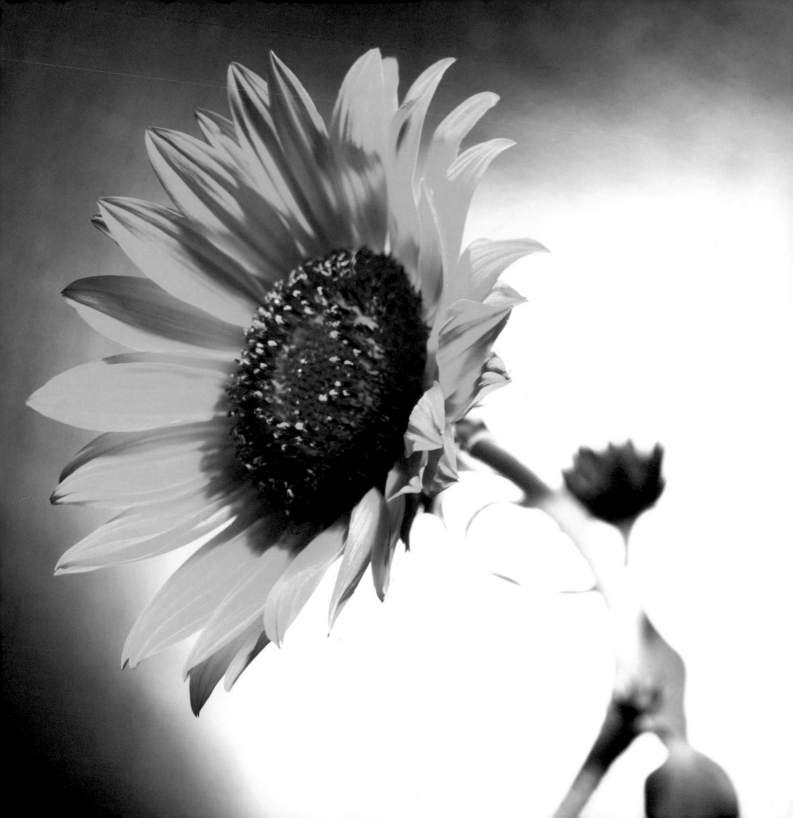

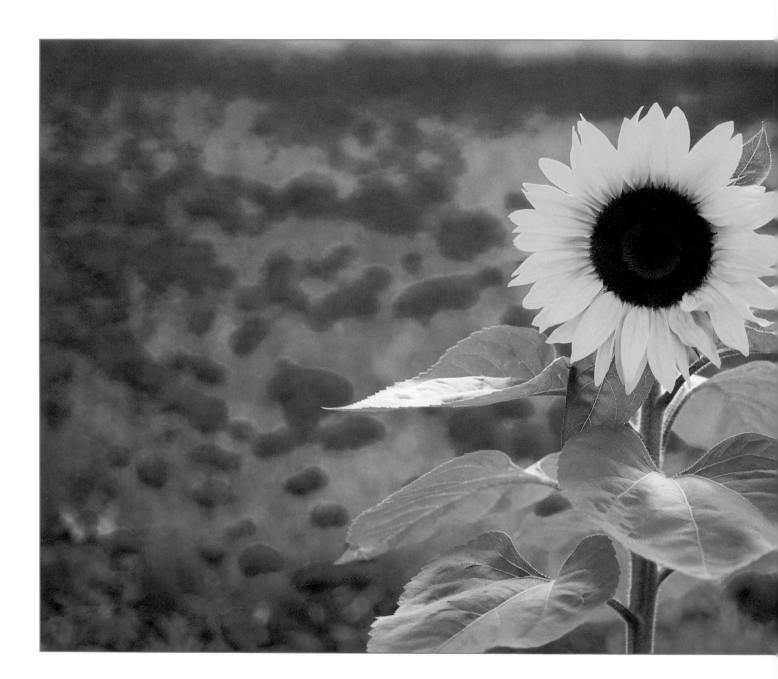

A book is the only place in which

you can examine

a fragile thought without breaking it,

or explore an explosive idea without fear it will

go off in your face. . . .

It is one of the few havens remaining

where a man's mind can get

both provocation and privacy.

Edward P. Morgan (1910–1993)

A work of art is part of nature

seen through a temperament.

André Gide (1869–1951)
French writer

ART is man

added TO NATURE.

Francis Bacon (1561–1626)
English philosopher and writer

You have your brush, you have your colors,

you paint paradise, then in you go.

Nikos Kazantakis (1885–1957)
Greek writer

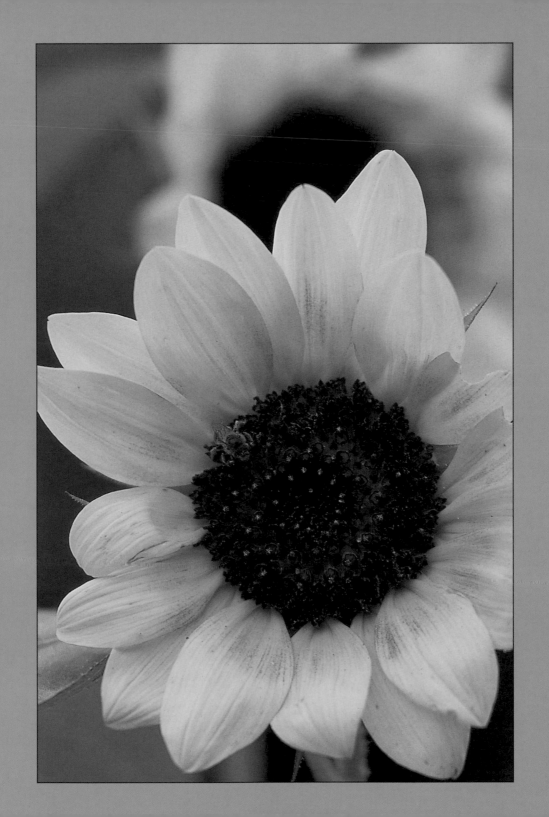

The object of art

is to give life

SHAPE.

Jean Anouilh (1910–1987)
French playwright

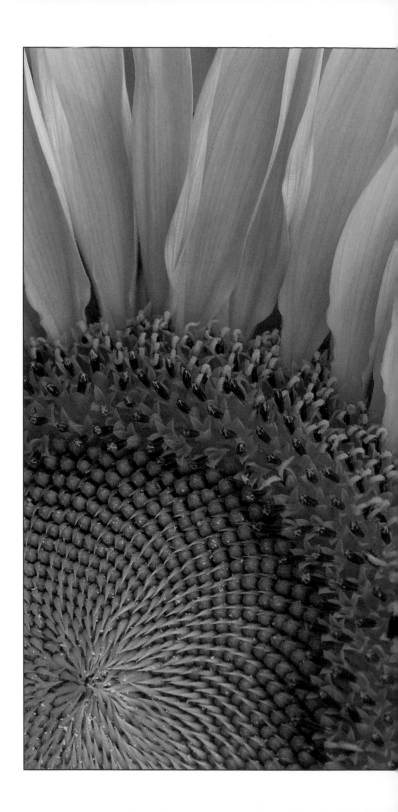

WHAT WAS ANY ART

but an effort

TO MAKE A SHEATH,

a mould,

in which to imprison

FOR A MOMENT

the shining, elusive element

WHICH IS LIFE ITSELF.

Willa Cather (1876–1947)
American writer

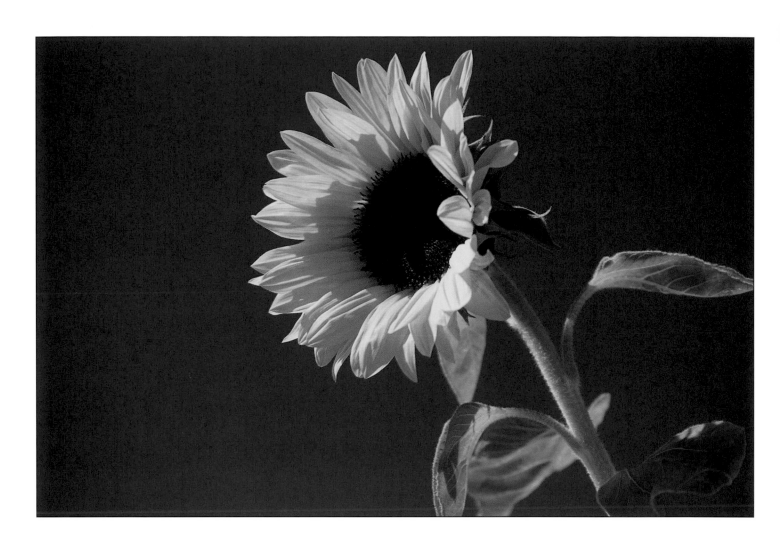

Nothing is wrong

WHEN DONE TO MUSIC.

Jerome Kern (1885–1945)

American composer

I am always thirsting for

beautiful, beautiful, beautiful

music.

I wish I could make it.

Perhaps there isn't any music on earth

like what I picture

to myself.

Olive Schreiner (1855–1920)
South African writer

Each flower is a soul

opening out to nature.

Gérard D. Nerval (1805–1855)

On with the dance! Let joy be unconfined;

No sleep till morn, when Youth and Pleasure meet

To chase the glowing Hours with flying feet.

George Gordon, Lord Byron (1788–1824)
English poet

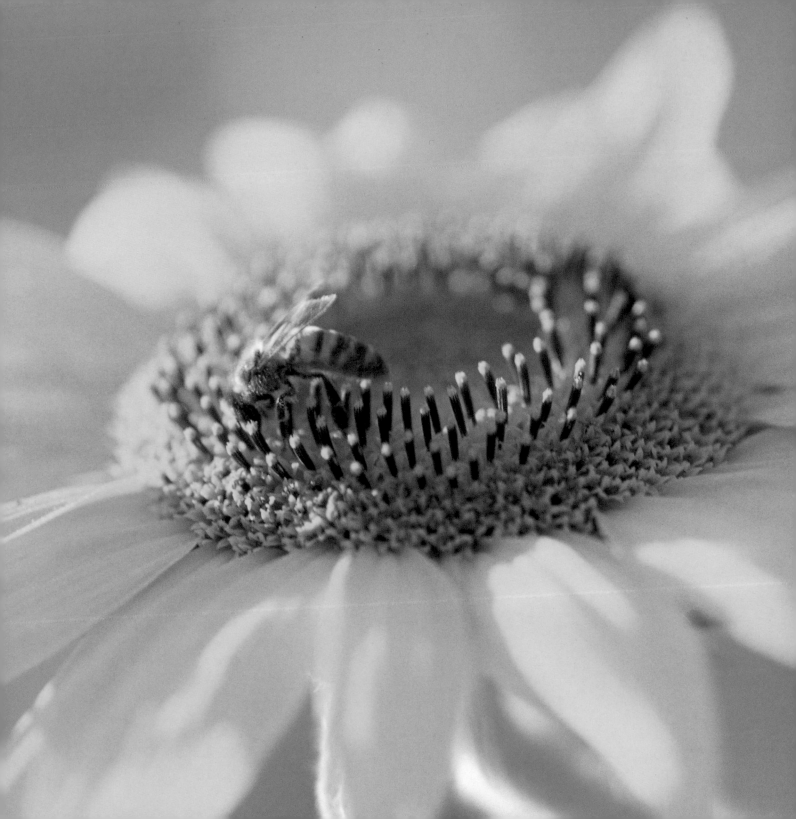

The connoisseur of art must be able to appreciate

what is simply beautiful,

but the common run of people are satisfied

with ornament.

Johann W. van Goethe (1749–1832)

LIFE SEEMS TO GO ON WITHOUT EFFORT,

WHEN I AM FILLED WITH MUSIC.

George Eliot [Mary Ann Evans] (1819–1880)
English writer

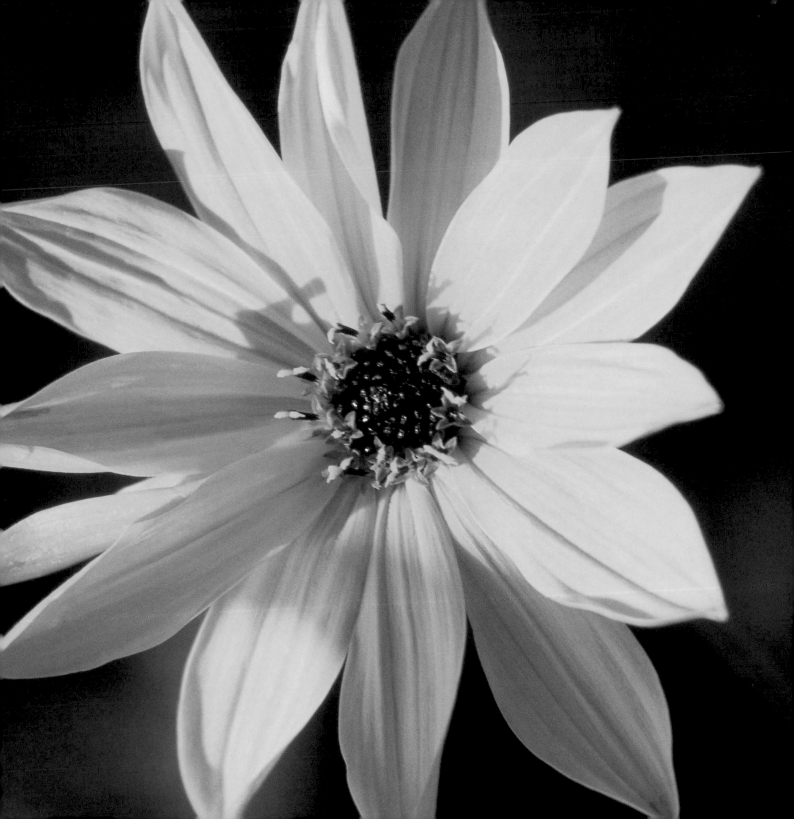

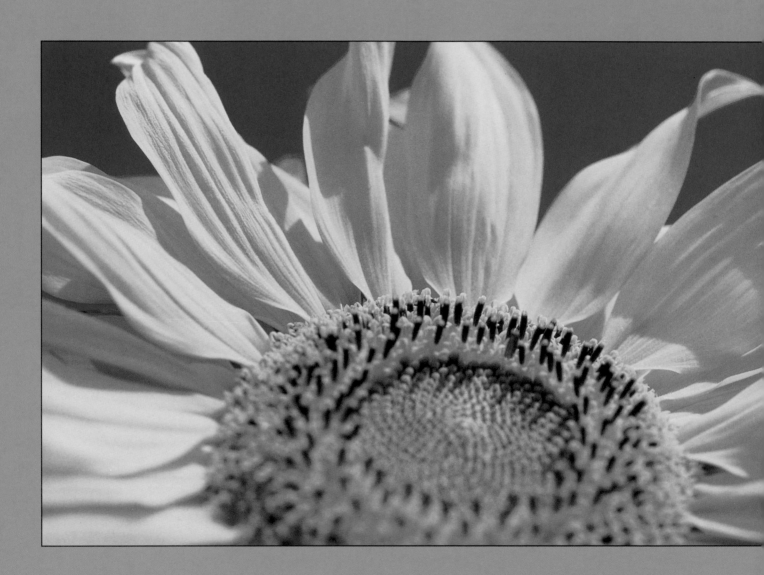

HEARD

MELODIES are sweet,

but those unheard are SWEETER.

John Keats (1795–1821)
English poet

When music sounds, gone is the earth I know.

And all her lovely things lovelier grow.

Walter de la Mare (1873–1956)
English poet and writer

Dance till the stars

come down from the rafters;

Dance, dance, dance . . .

W. H. Auden (1907–1973)
English-born American poet

Dance. . . . The body can fly without wings.

It can sing without voice.

The dance is strong magic. The dance is life.

Pearl Primus (1919–1994)
American dancer

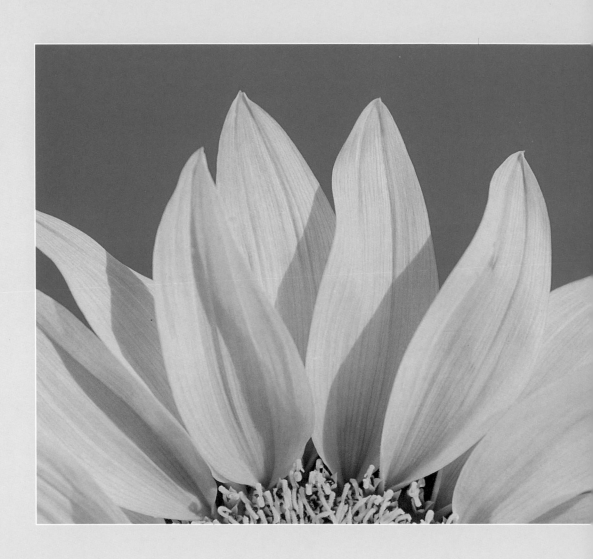

JOY

The most evident token and

APPARENT SIGN OF TRUE WISDOM

is a constant and

unconstrained

rejoicing.

Michel de Montaigne (1533–1592)
French essayist and thinker

Find expression for sorrow, and

it will become dear to you. Find expression for a joy,

and you will intensify its ecstasy.

Oscar Wilde (1854–1900)
Irish playwright

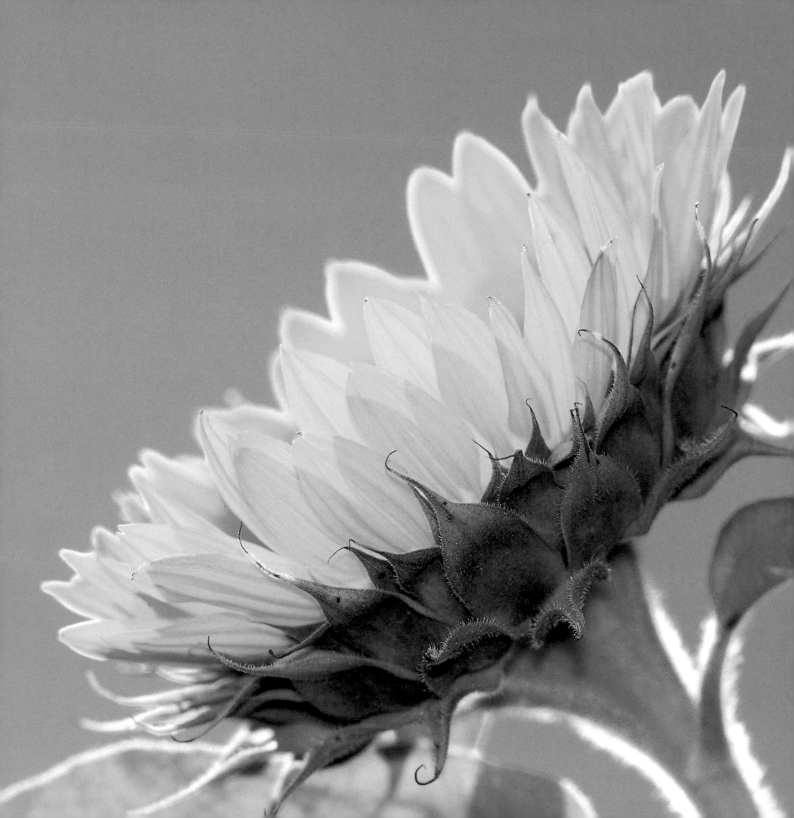

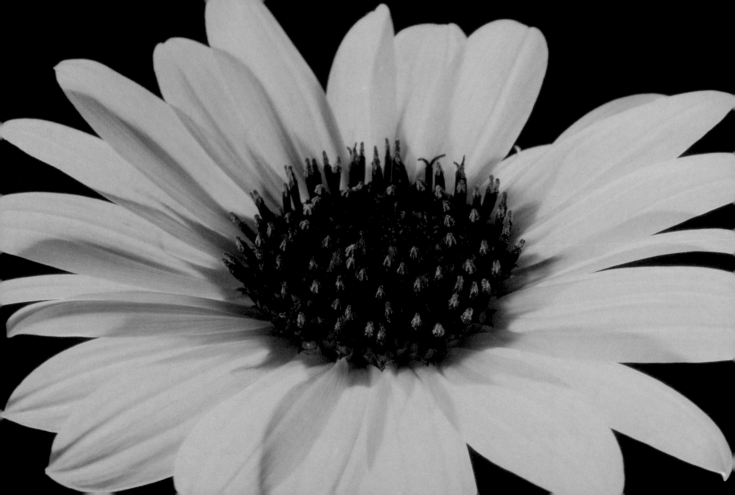

TRUE JOY IS SERENE.

Seneca (c. 4 B.C.– 65 A.D.)
Roman statesman and philosopher

Sun up, sun down, the days slip by and the sand lifted

by the breeze will swallow my ship; but I will die here,

as I am, standing in my little garden. What joy!

Simone Schwarz-Bart (b. 1938)
Gaudeloupean author

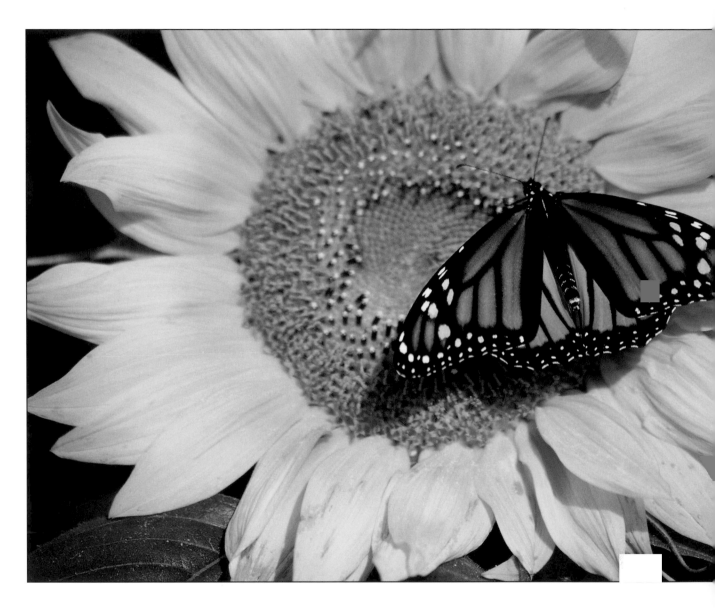

Joy is a net of love by which you catch souls . . .

Mother Teresa (1910–1997)
Founder, Missionaries of Charity

"On with the dance,

let joy be unconfined" is my motto,

whether there's any

dance to dance

or any joy to unconfine.

Mark Twain (1835–1910)
American writer

When in these fresh mornings I go into my garden before anyone is awake. I go for the time being into perfect happiness. In this hour divinely fresh and still, the fair face of every flower salutes me with a silent joy that fills me with infinite content; each gives me its color, its grace, its perfume, and enriches me with the consummations of its beauty. All the cares, perplexities, and griefs of existence, all the burdens of life slip from my shoulders and leave me with the heart of a little child that asks nothing beyond its present moment of innocent bliss.

Celia Thaxter (1835–1894)
American writer

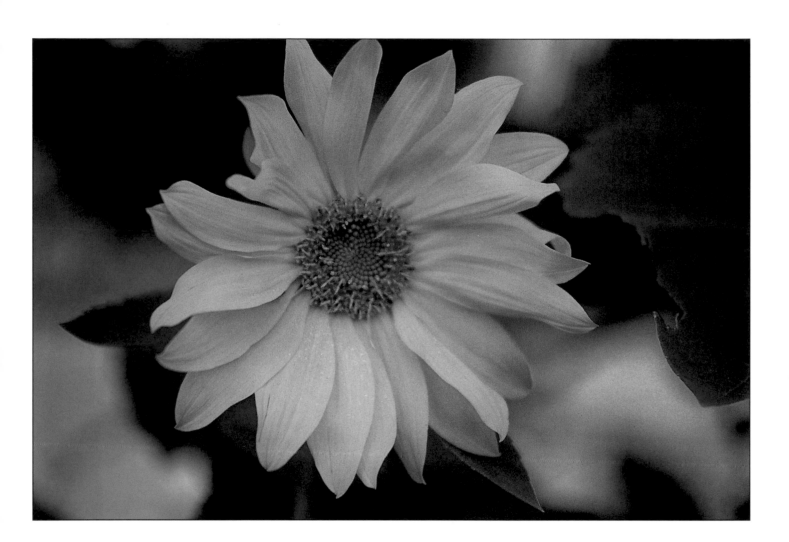

Weeping may endure for a night,
but joy cometh in the morning.

Psalms 30:5

O for a life of sensations rather
than of thoughts.

John Keats (1795–1821)
English poet

FLOWERS

OF THE SUN

In the middle of everything is

THE SUN.

Nicholas Copernicus (1473–1543)
Polish astronomer

O SUN,

Burn the great sphere thou mov'st in! Darkling stand

the varying shore o'th' world!

(from *Antony and Cleopatra*)
William Shakespeare (1564–1616)
British dramatist, poet

The sunset caught me,

turned the brush to copper, set the clouds to one

GREAT ROOF OF FLAME

ABOVE THE EARTH.

Elizabeth Coatsworth (1893–1986)
American writer

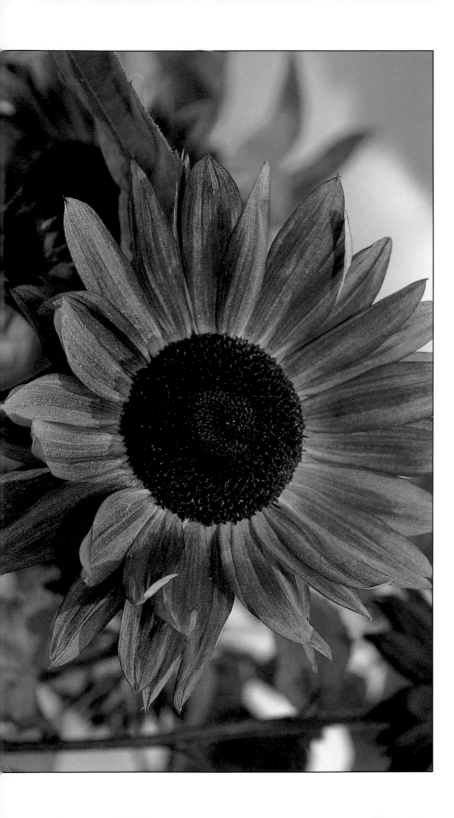

Pleasantly, between the

pelting showers,

the sunshine gushes down.

William Cullen Bryant (1784–1887)
American poet

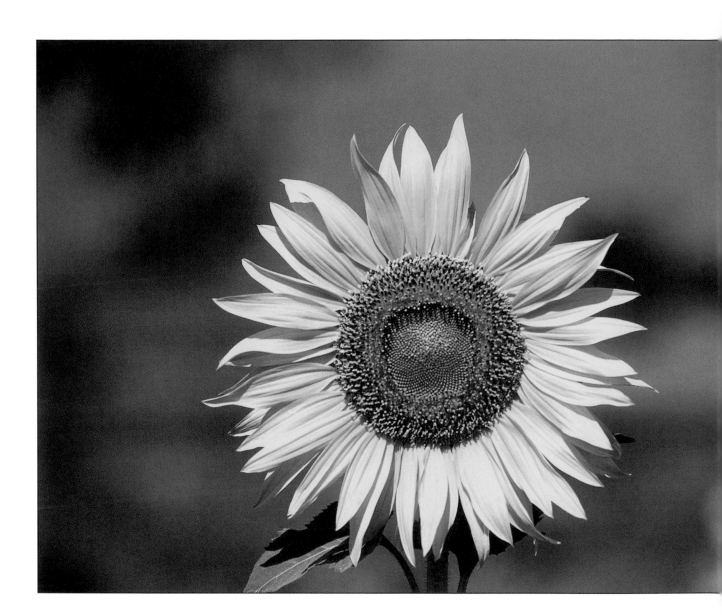

Life is the fire

that burns and the sun

that gives light.

Life is the wind and the rain

and the thunder in the sky. Life is

matter and is

earth, what is and what is not, and

what beyond is

in Eternity.

Upanishads

The glorious lamp of heaven, the sun.

Robert Herrick (1591–1674)
English poet

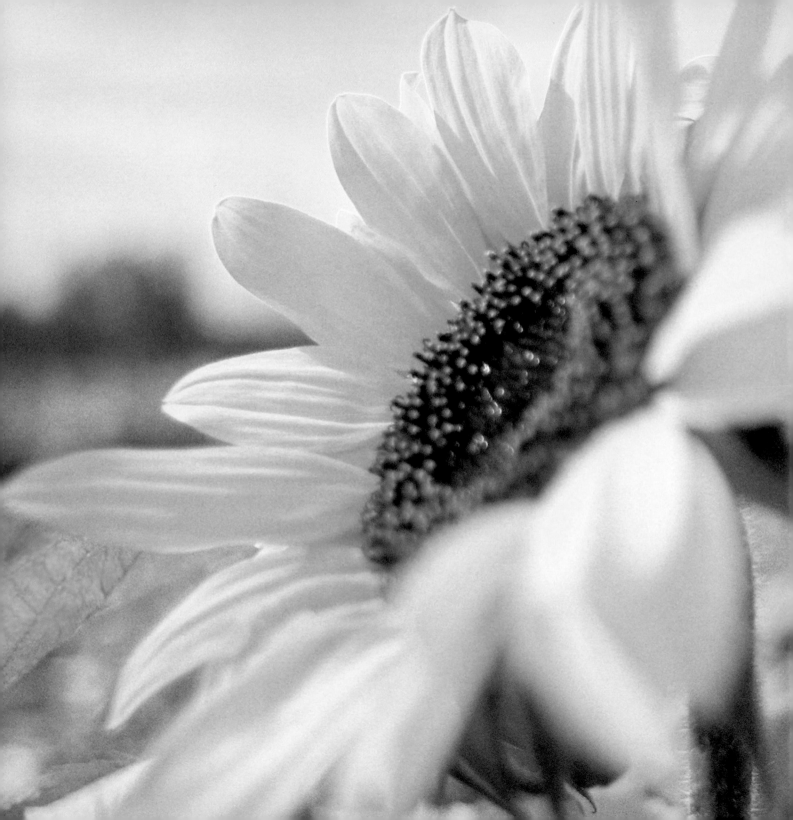

He that has light
within his own clear breast

MAY SIT IN THE CENTRE, AND
ENJOY BRIGHT DAY:

But he that hides a dark soul
and foul thoughts

Benighted walks under the mid-day sun;

HIMSELF HIS OWN
DUNGEON.

John Milton (1608–1674)
English poet

...THE CENTRE AND SOUL

OF OUR SYSTEM...

THE FOUNTAIN OF COLOR,

WHICH GIVES ITS AZURE

TO THE SKY,

ITS VERDUE TO THE FIELDS,

ITS RAINBOW HUES

TO THE GAY WORLD

OF FLOWERS,

AND THE PURPLE LIGHT OF LOVE

TO THE MARBLE CHEEK

OF YOUTH AND BEAUTY.

Sir David Brewster (1781–1868)
Scottish physicist

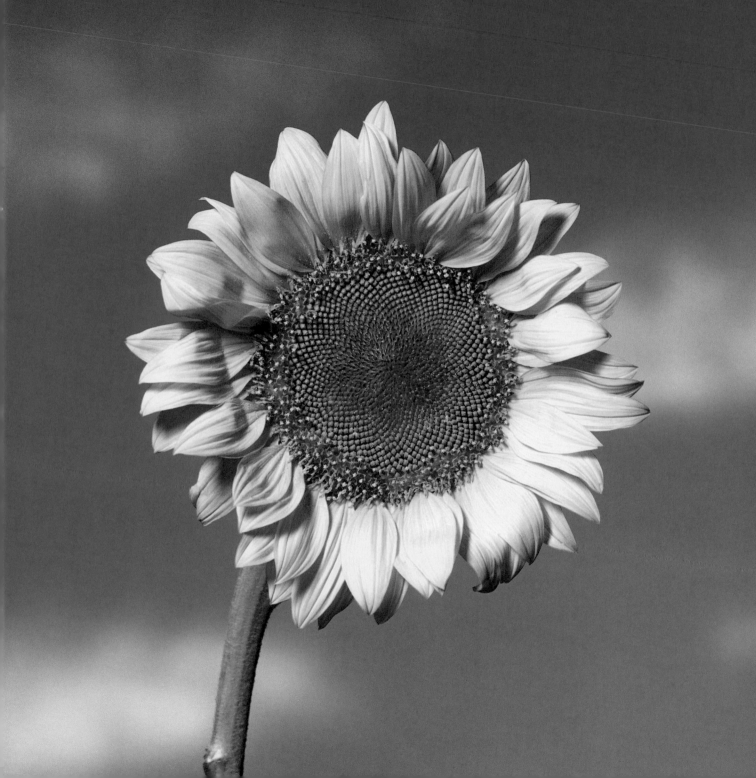

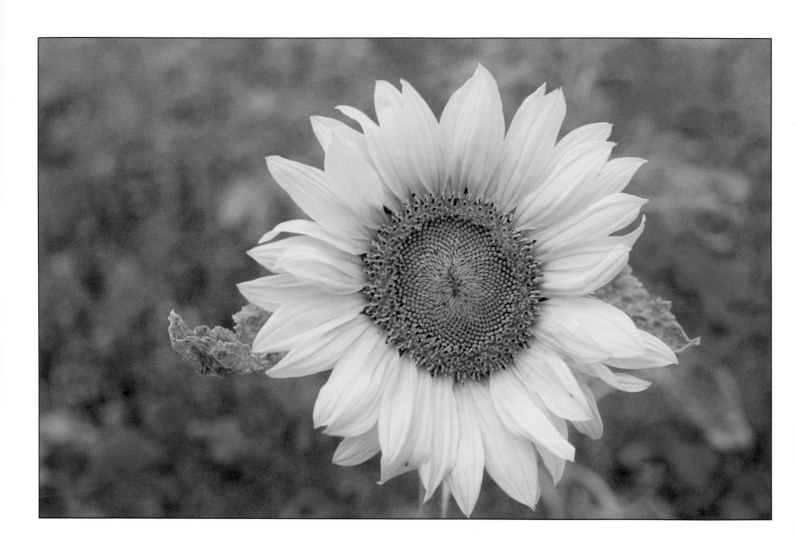

. . . the light is sweet, and a pleasant thing it is
for the eyes to behold the sun.

Ecclesiastes 11:7

BREATHLESS,

we flung us on the windy hill,

LAUGHED IN THE SUN,

and kissed the lovely grass.

Rupert Brooke (1887–1915)
English poet

It is always sunrise

somewhere;

the dew is never all dried at once;

a shower is forever falling;

vapor is ever rising.

Eternal sunrise, eternal sunset,

eternal dawn . . .

John Muir (1838–1914)
American naturalist

Photography credits

Front and back covers: © Corbis Images / PictureQuest

p. 2: © Bonnie Sue

p. 6: © Corbis Images / PictureQuest

p. 7: © Corbis Images / PictureQuest

p. 8: © Norma Walton / Flowerphotos.com

p. 11: © Bonnie Sue

p. 12: © Ron Chapple / Thinkstock / PictureQuest

p. 15: © Bjanka Kadic / Flowerphotos.com

p. 16: © Corbis Images / PictureQuest

p. 19: © Bonnie Sue

p. 20: © Gill Orsman / Flowerphotos.com

p. 22: © David Wasserman / Brand X Pictures / PictureQuest

p. 25: © Corbis Images / PictureQuest

p. 26: © Jonathan Buckley / Flowerphotos.com

p. 29: © David Wasserman / Brand X Pictures / PictureQuest

p. 30: © Jane Butler / Flowerphotos.com

p. 33: © Corbis

pp. 34–35: © DigitalVision / PictureQuest

p. 37: © DigitalVision / PictureQuest

p. 38: © David Wasserman / Brand X Pictures / PictureQuest

p. 40: © Paul Debois / Flowerphotos.com

p. 42: © Stockbyte / PictureQuest

p. 45: © Bonnie Sue

p. 46: © Paul Debois / Flowerphotos.com

p. 48: © Gill Orsman / Flowerphotos.com

p. 51: © Randy Allbritton / PhotoDisc / PictureQuest

p. 52: © Corbis

p. 55: © Bruce Curtis

p. 56: © Corbis

p. 58: © Corbis

p. 61: © Dave Zubraski / Flowerphotos.com

p. 63: © Moggy Ashton / Flowerphotos.com

p. 64: © Carol Sharp / Flowerphotos.com

p. 67: © Carol Sharp / Flowerphotos.com

p. 68: © DigitalVision / PictureQuest

p. 71: © Bonnie Sue

p. 72: © Mark Andersen / RubberBall Productions / PictureQuest

p. 74: © Corbis

p. 77: © Bruce Curtis

pp. 78–79: © Gill Orsman / Flowerphotos.com

p. 80: © Carol Sharp / Flowerphotos.com

p. 83: © DigitalVision / PictureQuest

p. 85: © Bonnie Sue

p. 86: © Corbis

pp. 88–89: © DigitalVision / PictureQuest

p. 91: © Corbis Images / PictureQuest

p. 92: © Andrew Ward / Life File / PhotoDisc / PictureQuest

p. 95: © Bonnie Sue